How to Draw
Cats

In Simple Steps

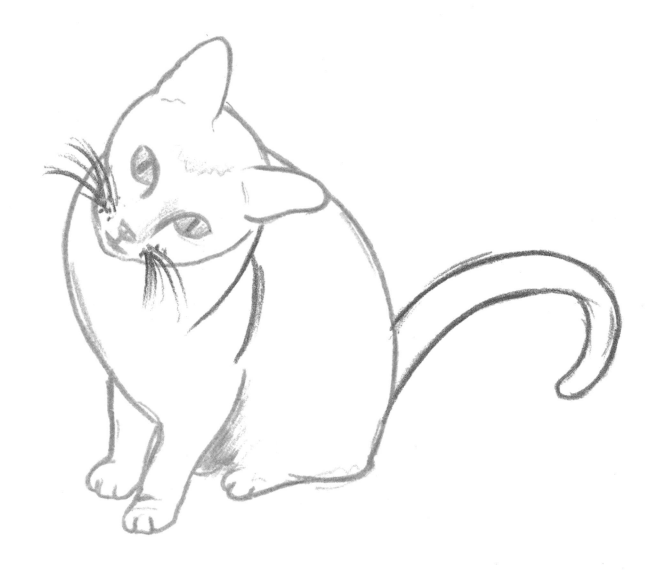

First published in Great Britain 2008

Search Press Limited
Wellwood, North Farm Road,
Tunbridge Wells, Kent TN2 3DR

Reprinted 2009, 2010 (twice)

Text copyright © Polly Pinder, 2008

Design and illustrations copyright © Search Press Ltd. 2008

ISBN: 978-1-84448-369-3

Printed in Malaysia

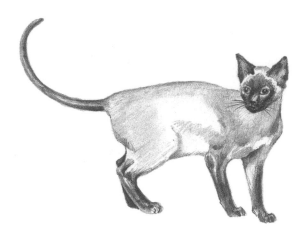

Dedication

*To my dear ERA friend Barbara and
her lovely cat Lump*

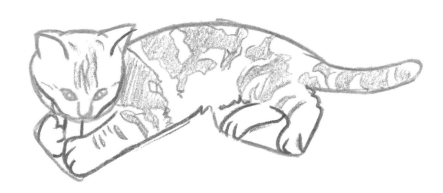

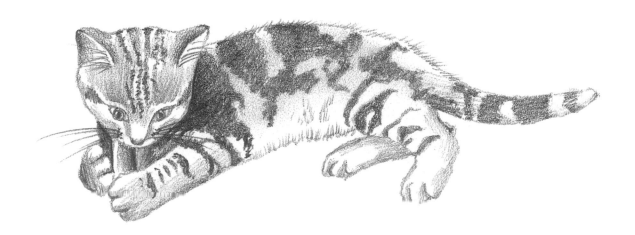

How to Draw
Cats

In Simple Steps
Polly Pinder

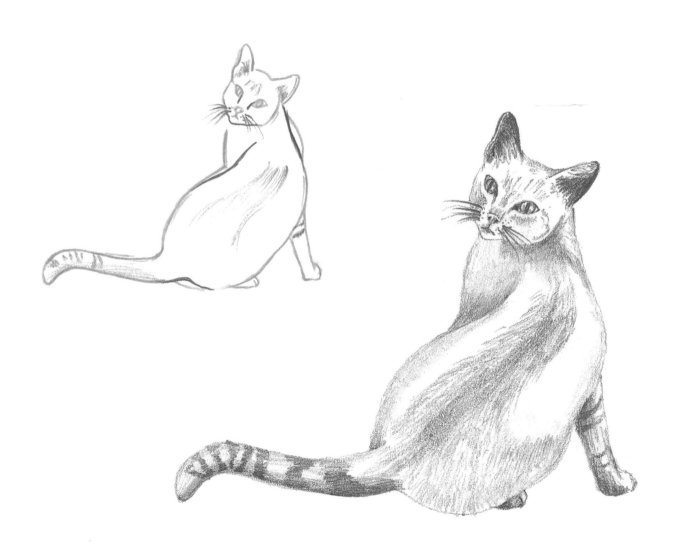

Search Press

Introduction

There is no denying that cats are beautiful animals to observe and draw whether the your chosen subject is a sweet, naughty kitten with large, beguiling eyes or a striking, sophisticated Siamese.

In the following pages I show how to draw a variety of breeds using a method in which simple shapes evolve, stage by stage, into the unmistakable form of specific cats. In order to make the sequences easier to follow, I use pink and turquoise coloured pencils for each of the five stages.

In the first stage I use pink, reducing the head and body to simple, circular shapes. Sometimes the suggestion of a neck is included as a line which joins these two shapes together. In the second stage the shapes drawn in stage one become turquoise and new shapes, such as ears and legs, are drawn in with the pink pencil. In the third stage, the previous drawing becomes turquoise and additional pink shapes are added, along with some facial details. The shapes become more feline in stage four, when pink whiskers, fur and paws are added. The fifth stage is drawn using a graphite pencil and a final image shows the cat painted in its natural colours.

When you are following the stages use an HB, B or a 2B pencil. Draw lightly so that any initial, unwanted lines can be erased easily. Your final work could be a detailed pencil drawing, as shown opposite, or the pencil lines can be drawn over using a technical pen, a ballpoint pen or a felt-tipped pen. Gently erase the original pencil lines at this point.

When you feel more confident about your drawing, you may want to introduce colour. I have used watercolours, but once you have the basic shape of the cat you can use pencil crayons, felt-tipped pens or pastels to create good effects.

I hope you will draw all the cats here and then go on to draw more, perhaps from photographs of your own pet, using the method I have shown. Using tracing paper to transfer shapes and lines to your drawing will make the process a little easier. Once you become familiar with the general anatomy of these beautiful animals, you will soon develop your own style of drawing.

Happy Drawing!

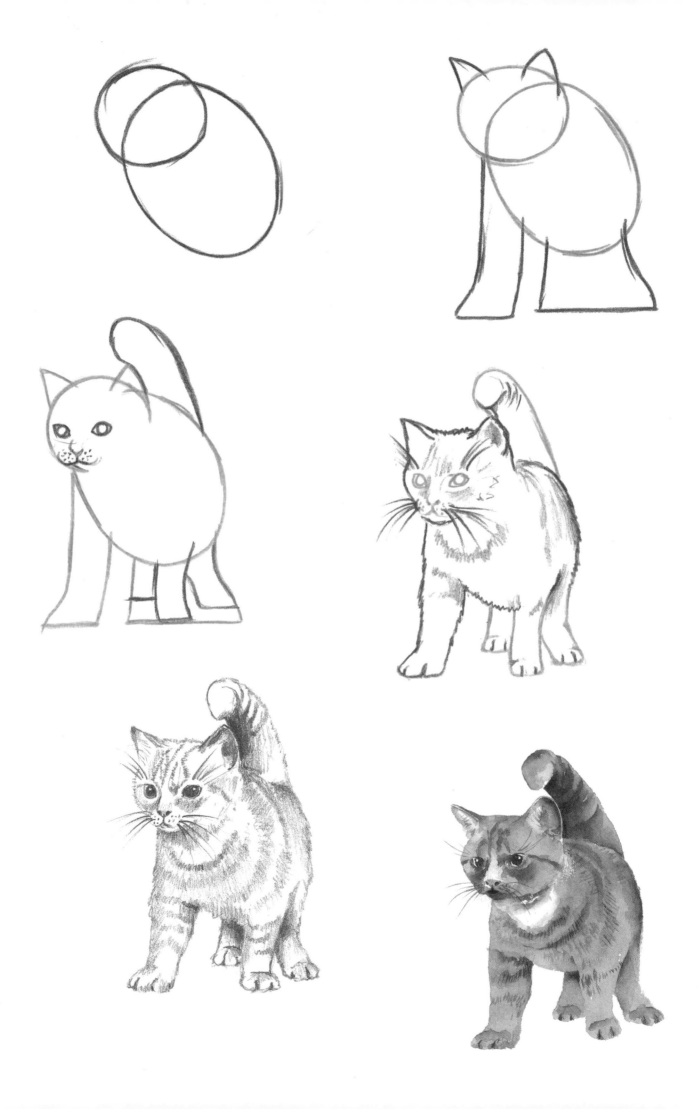

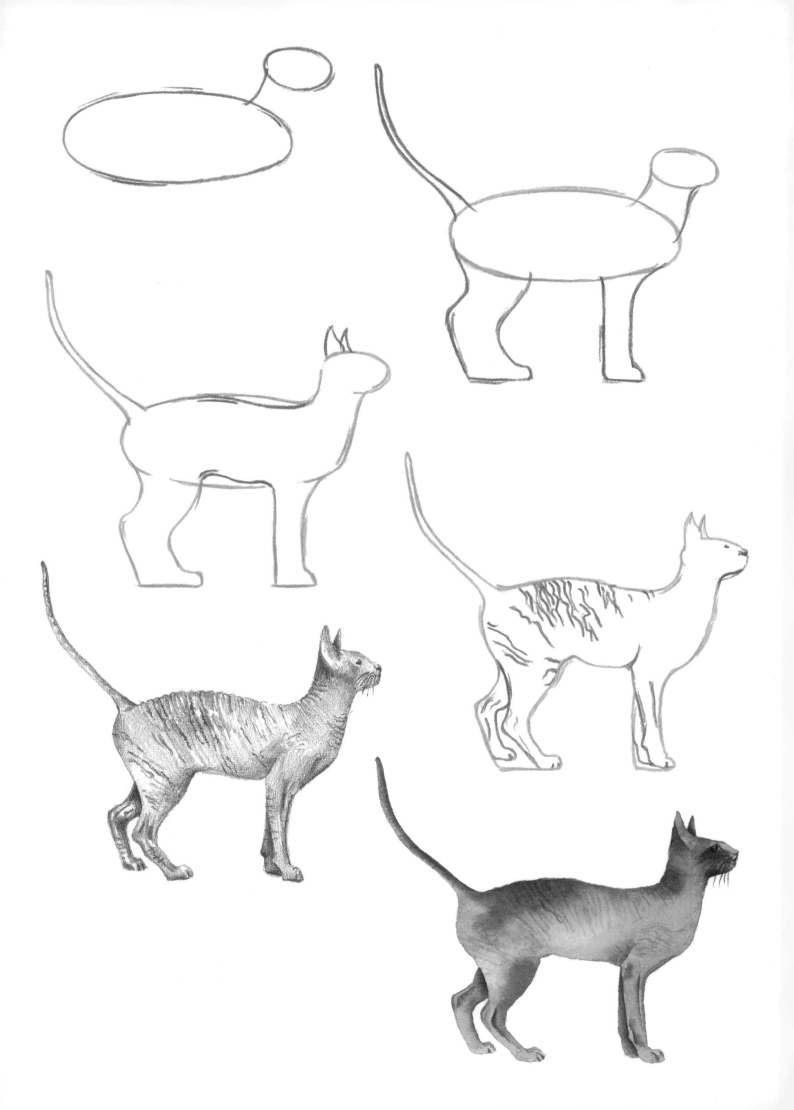

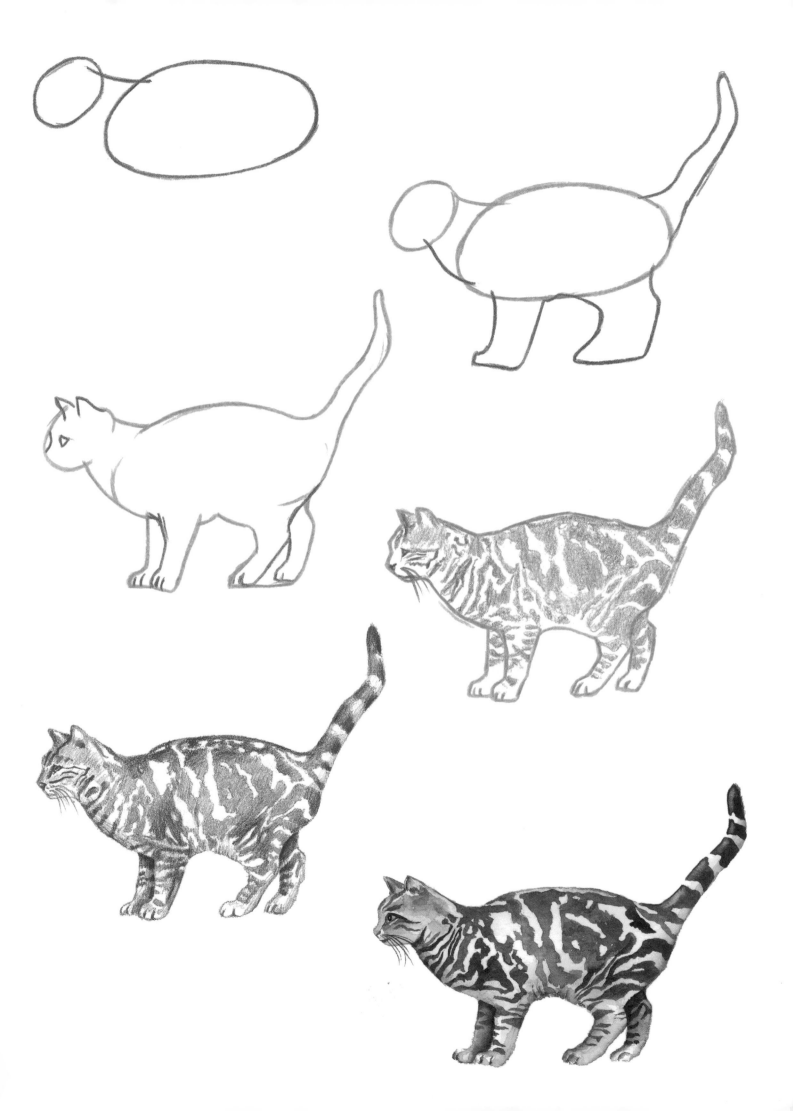

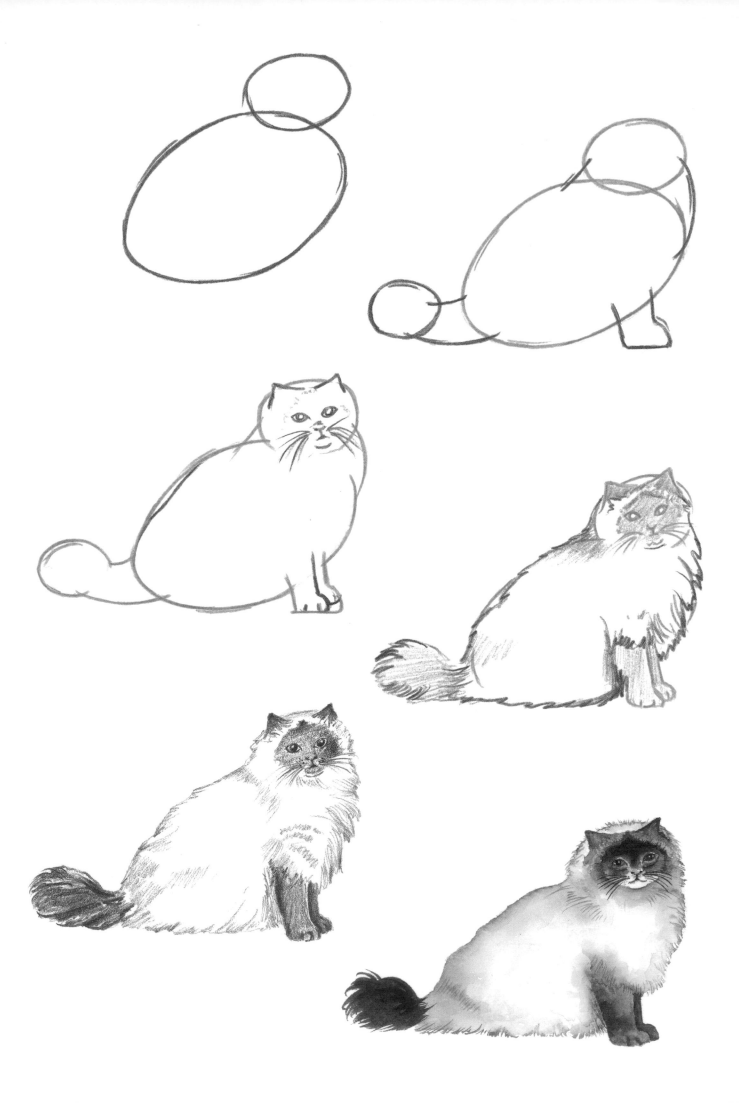

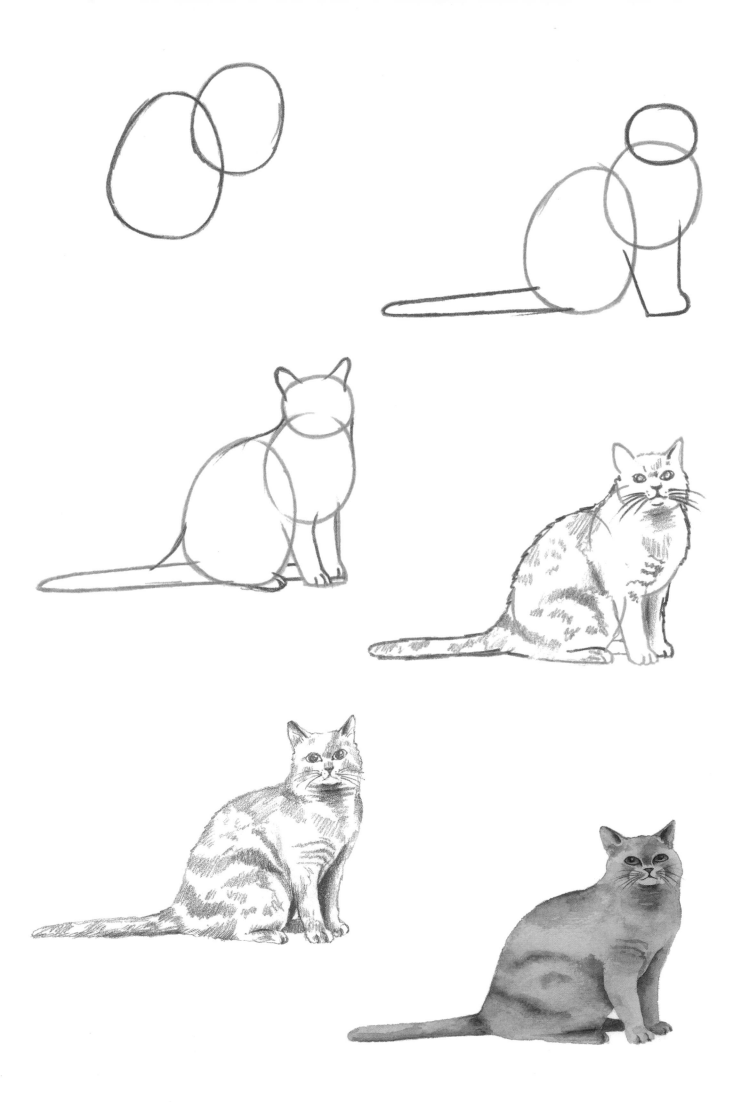

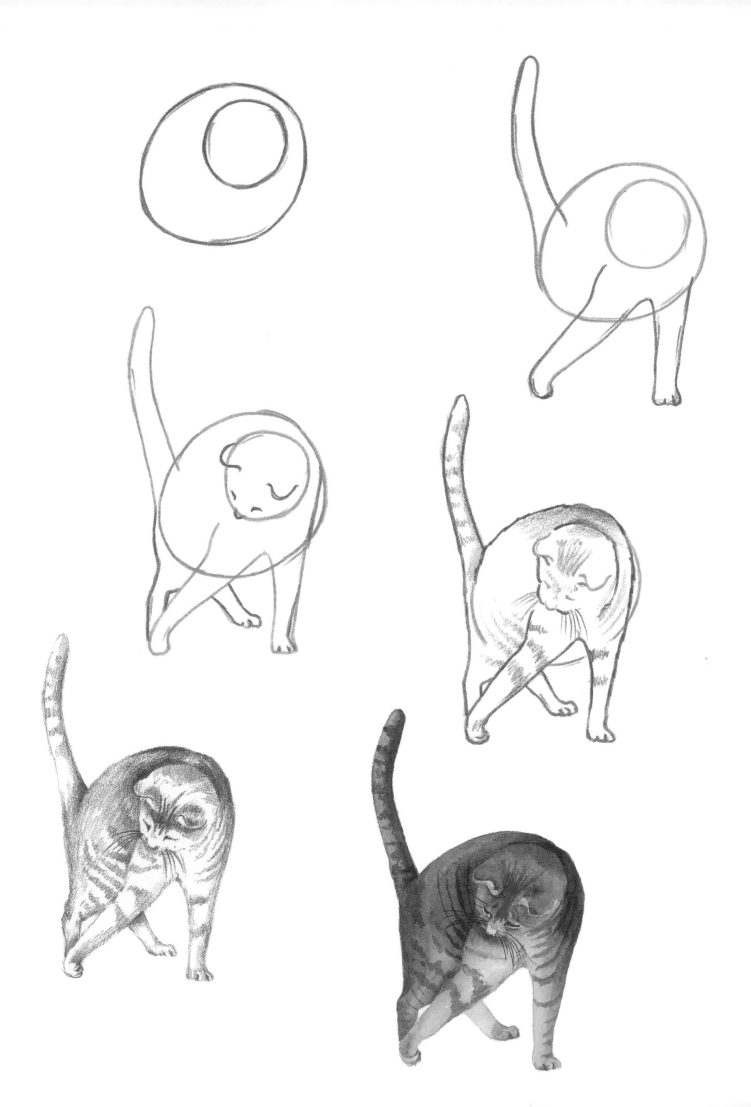

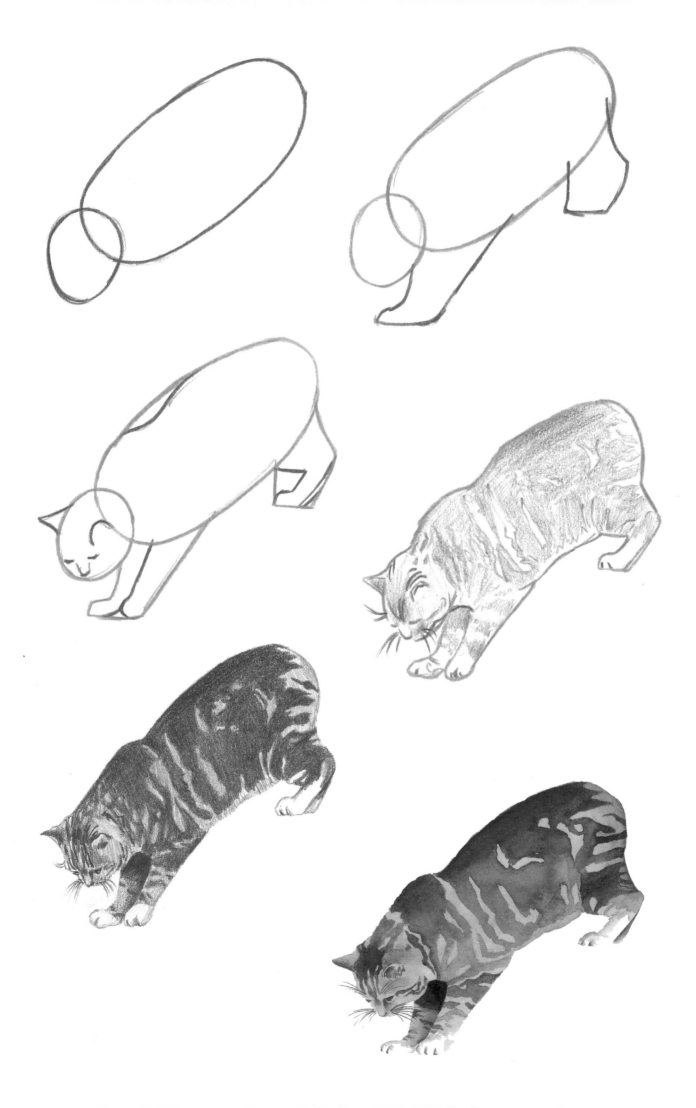

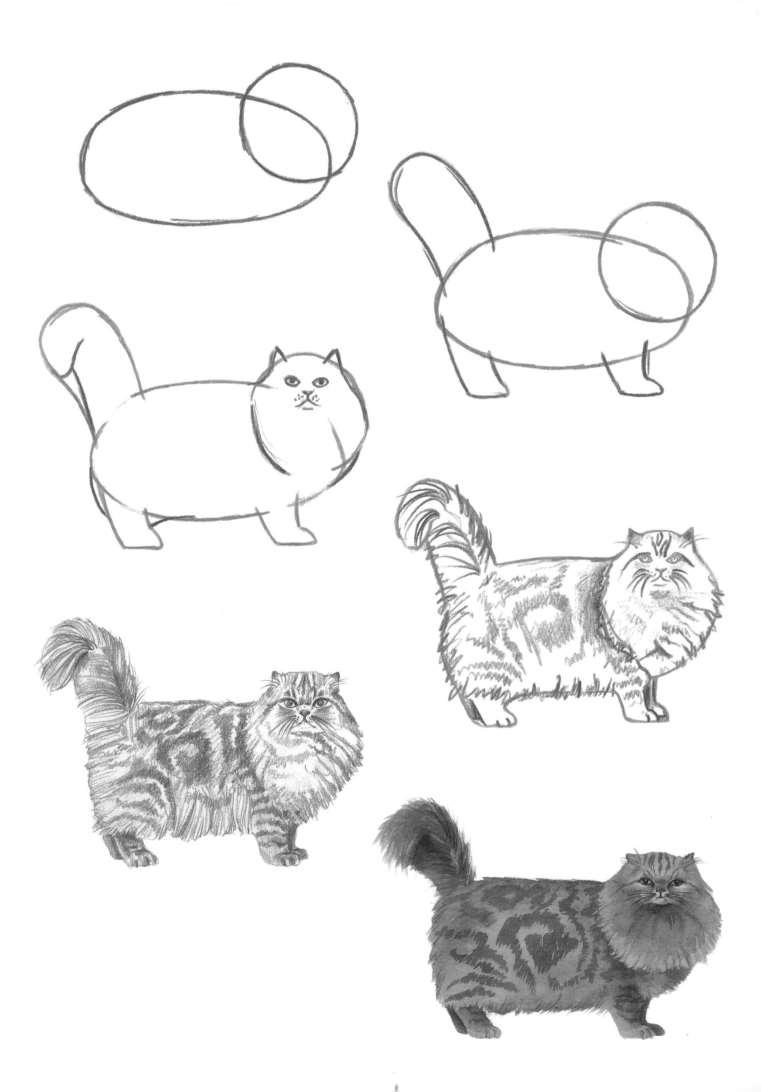

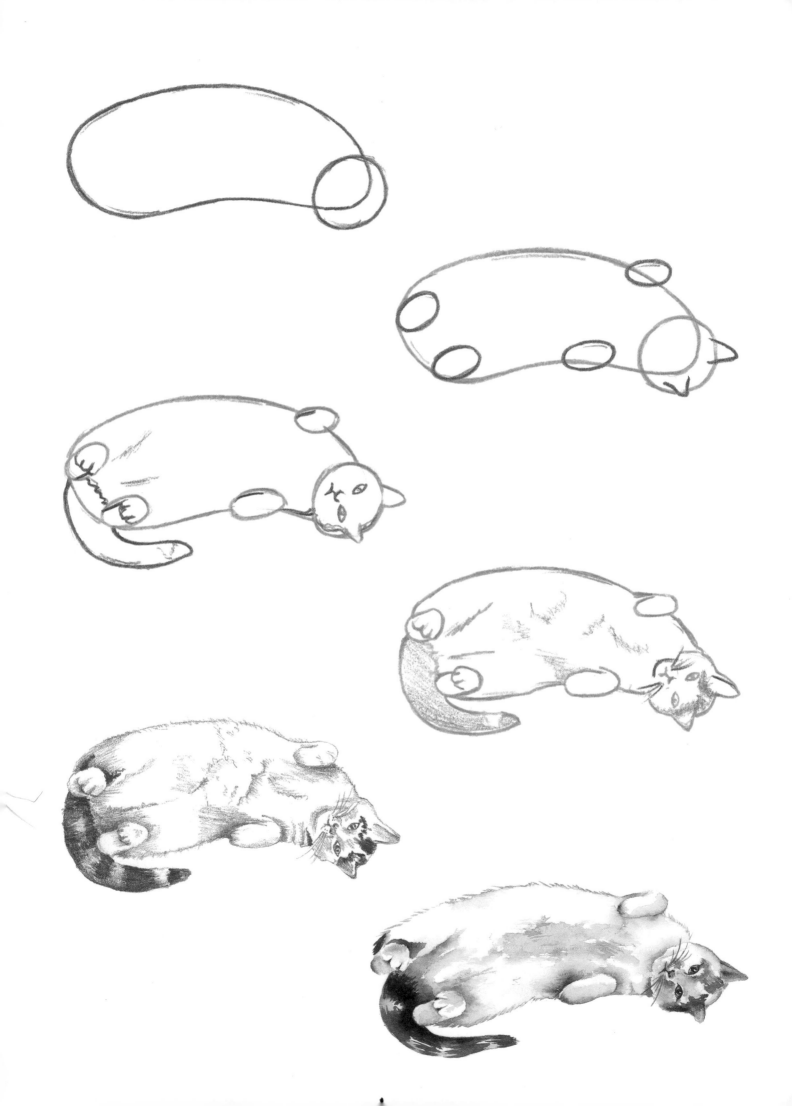

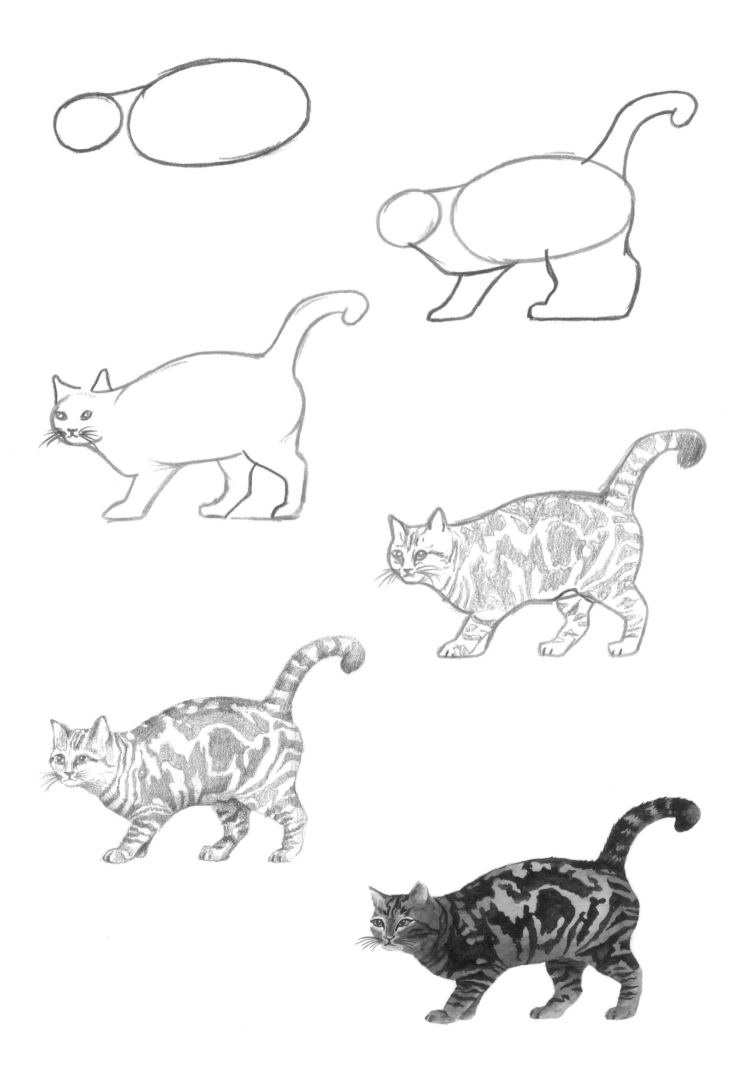

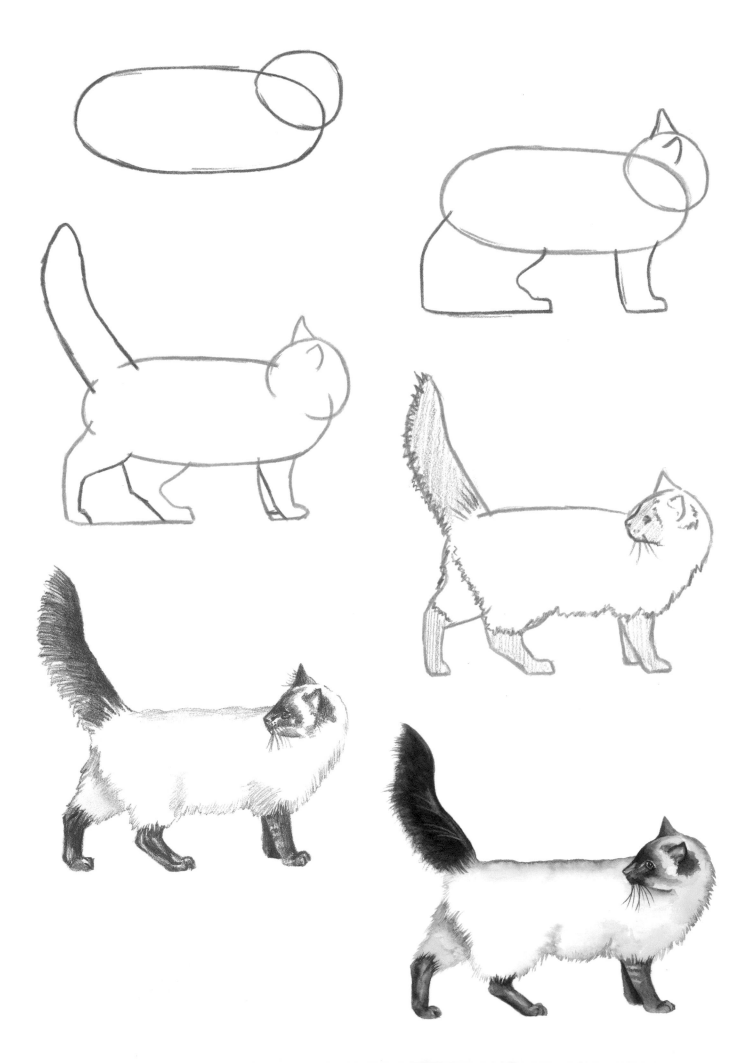

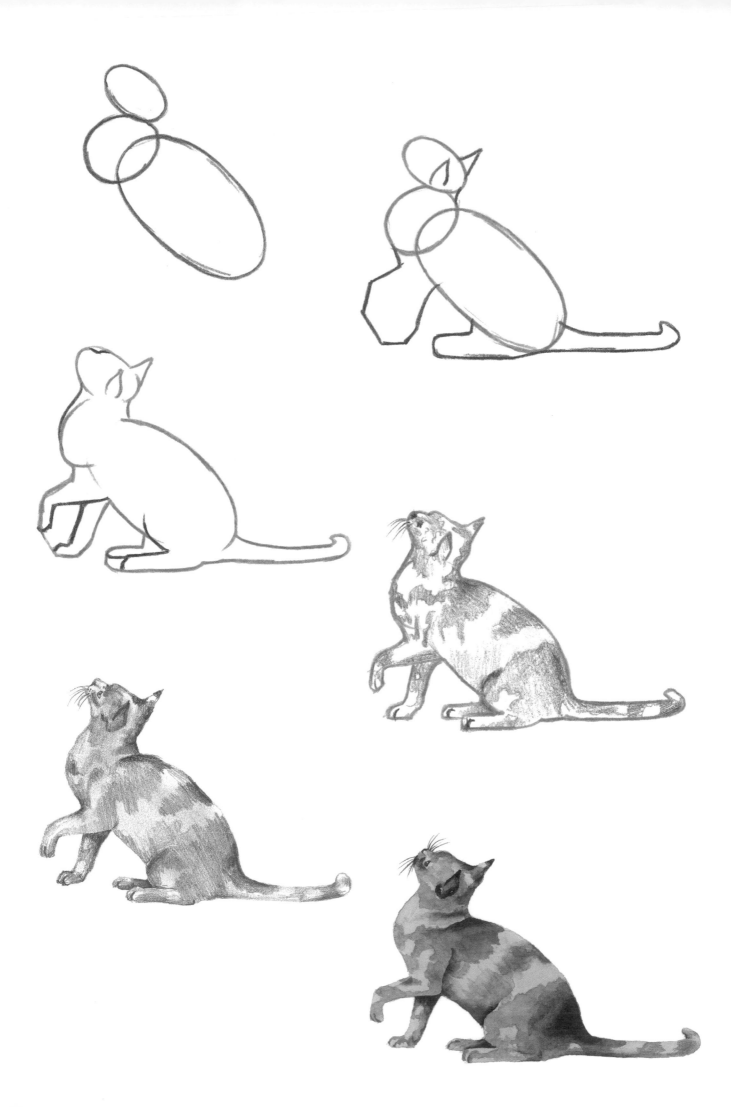

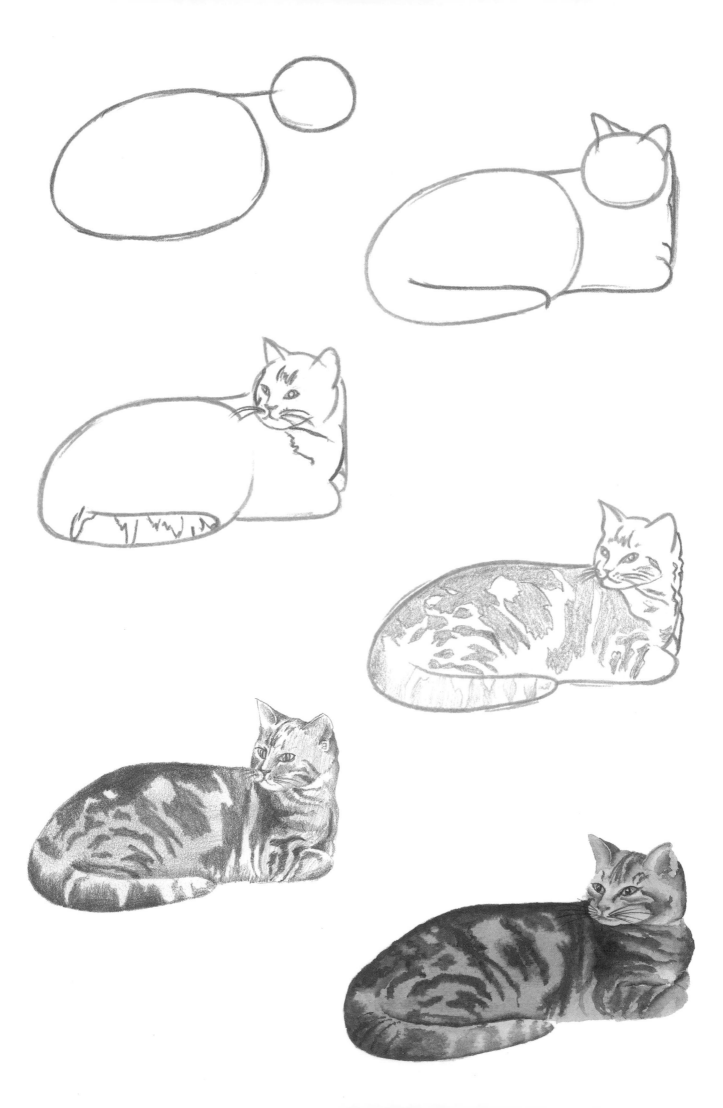

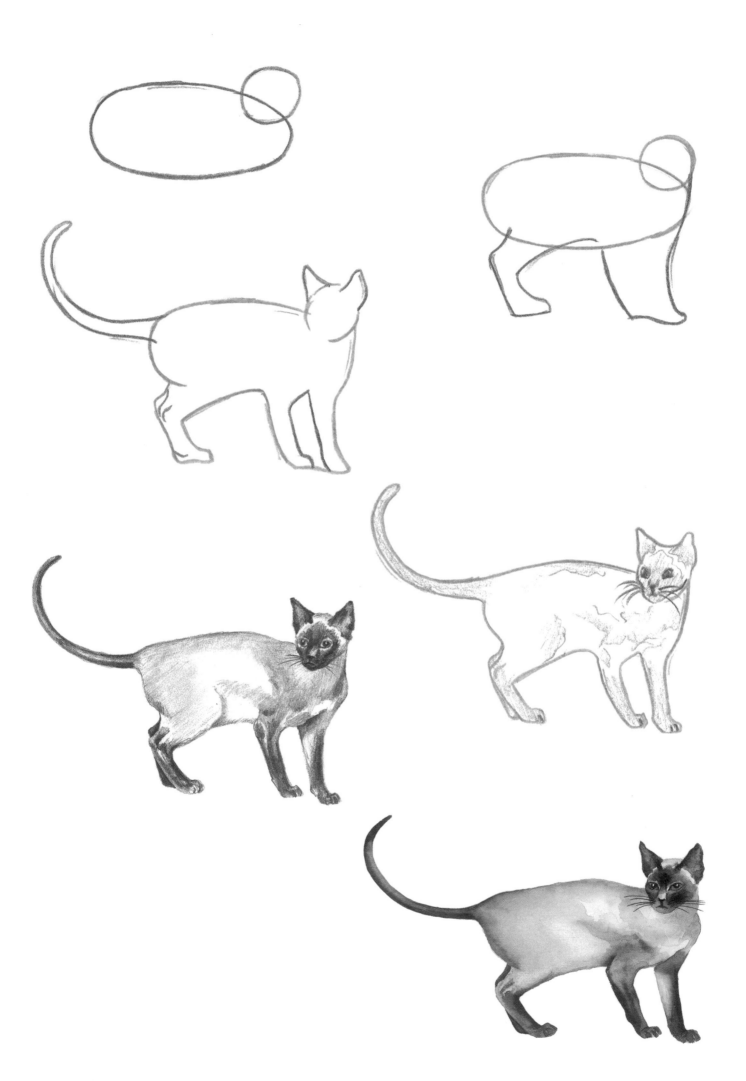

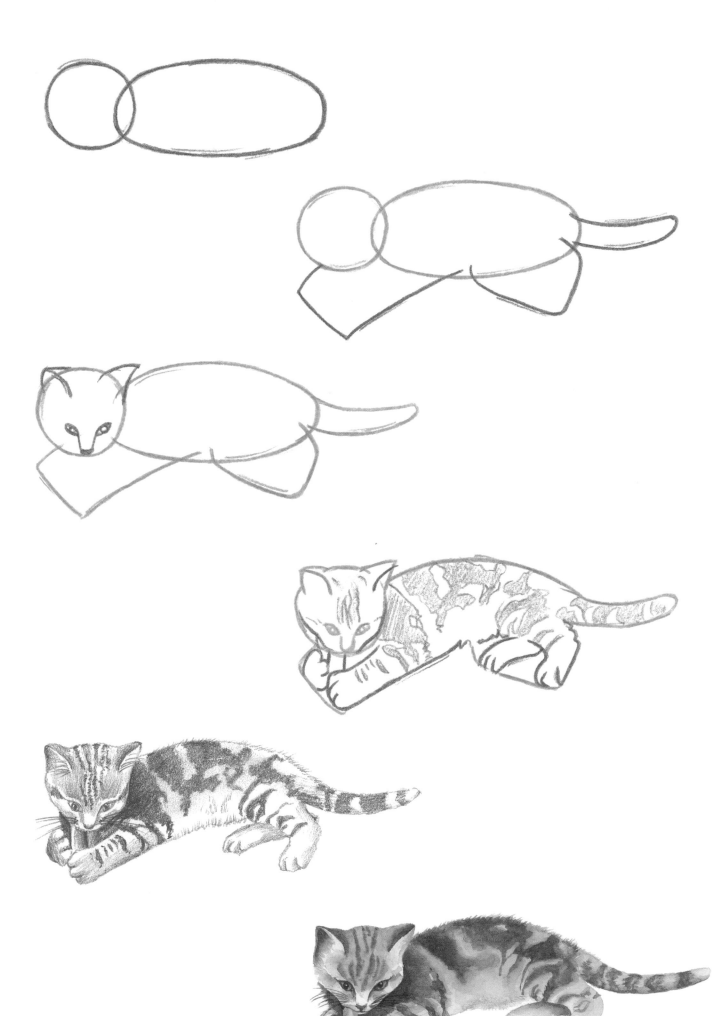

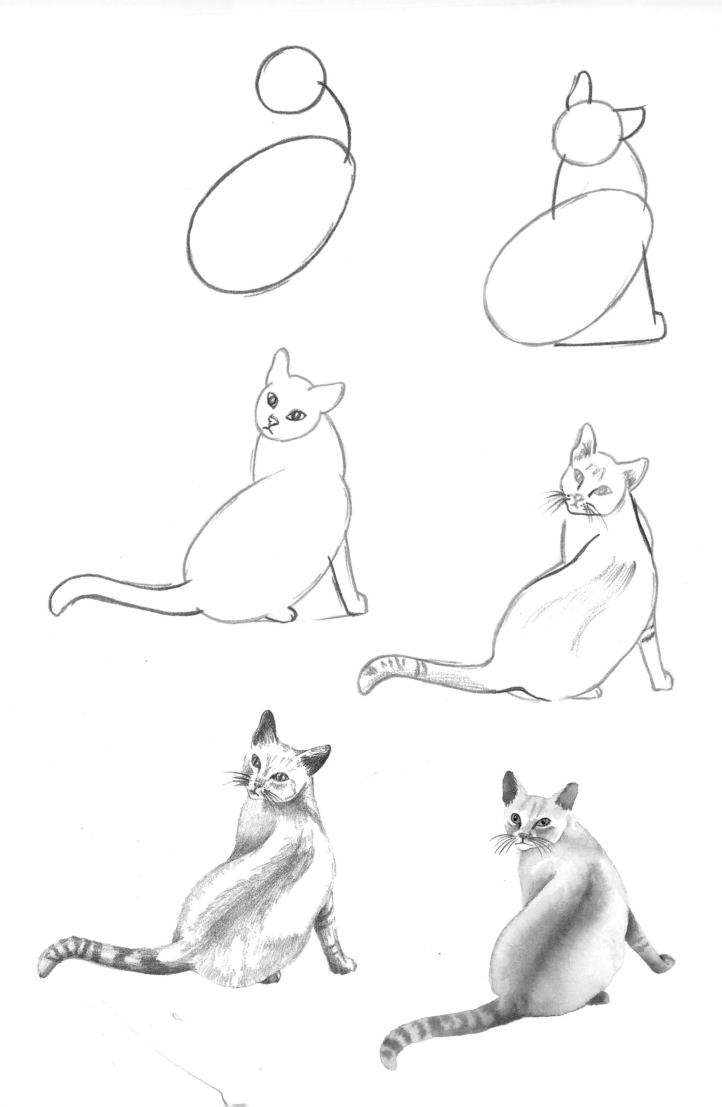

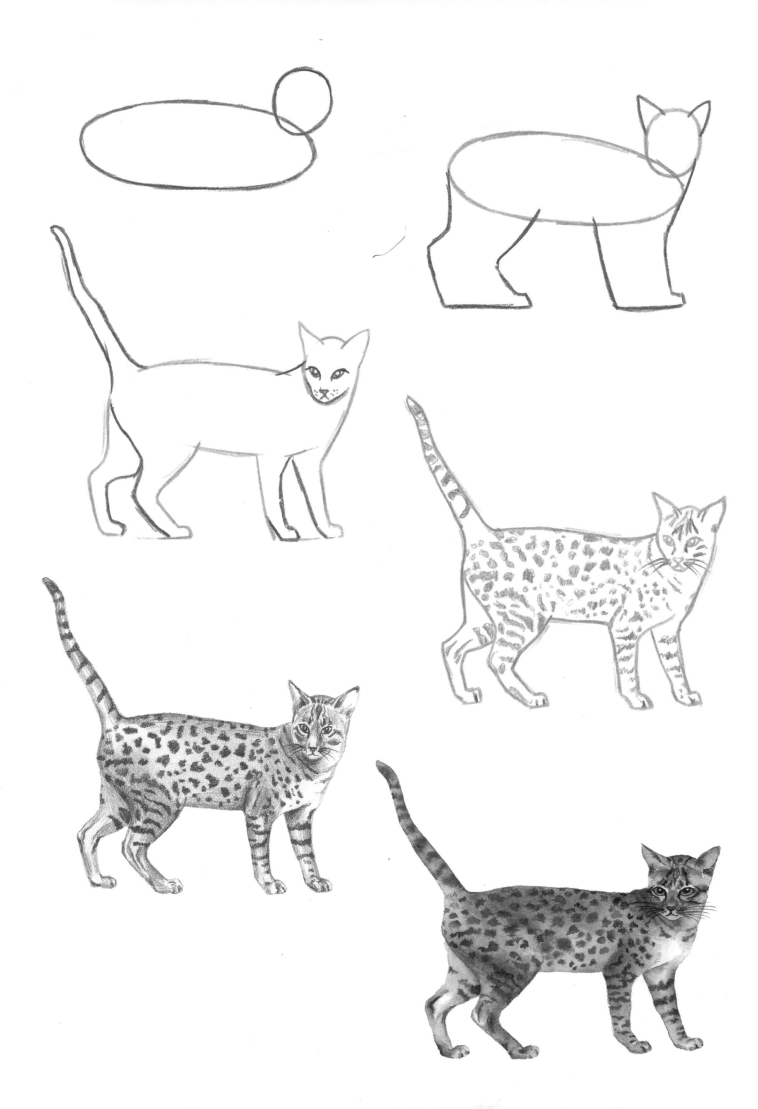

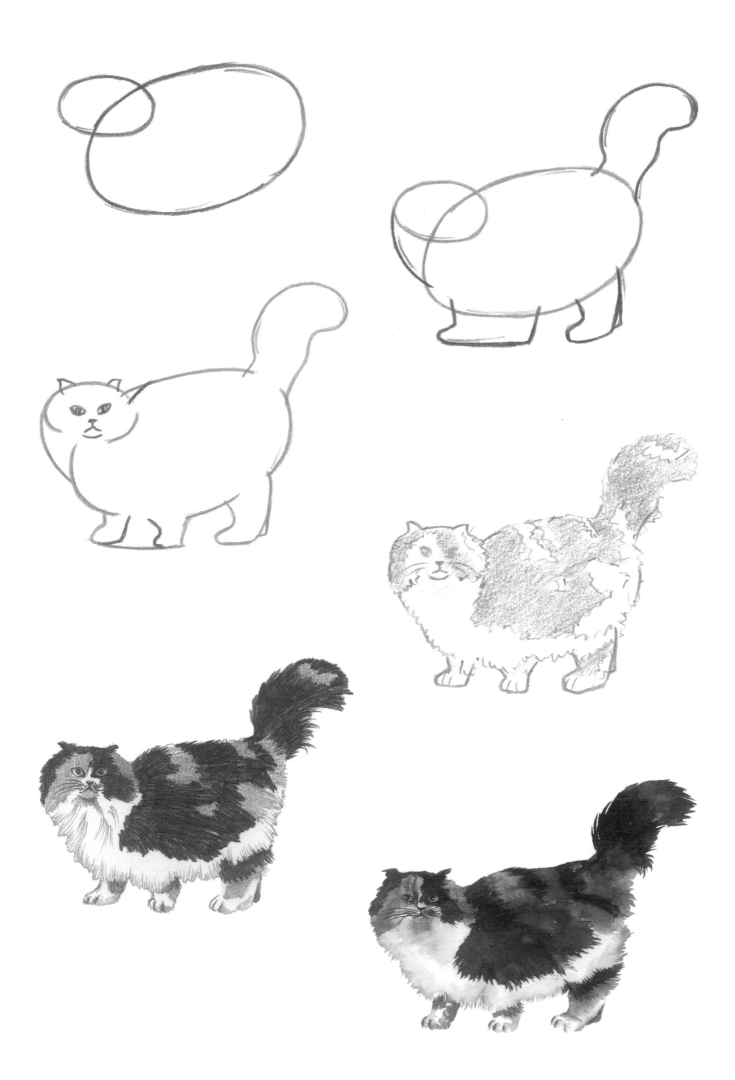

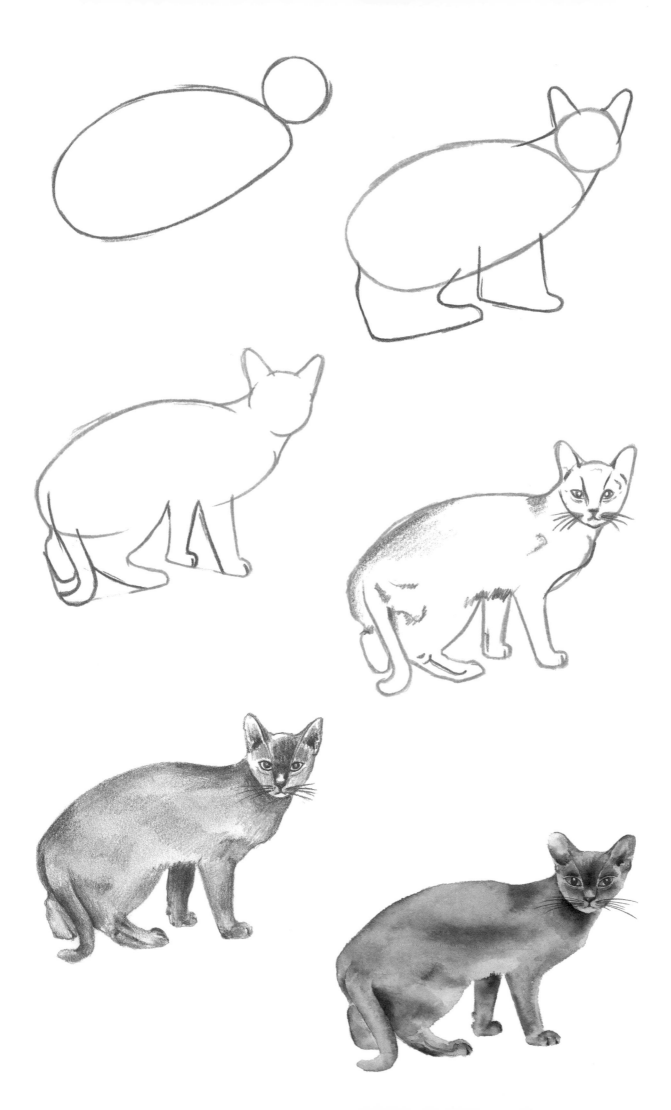

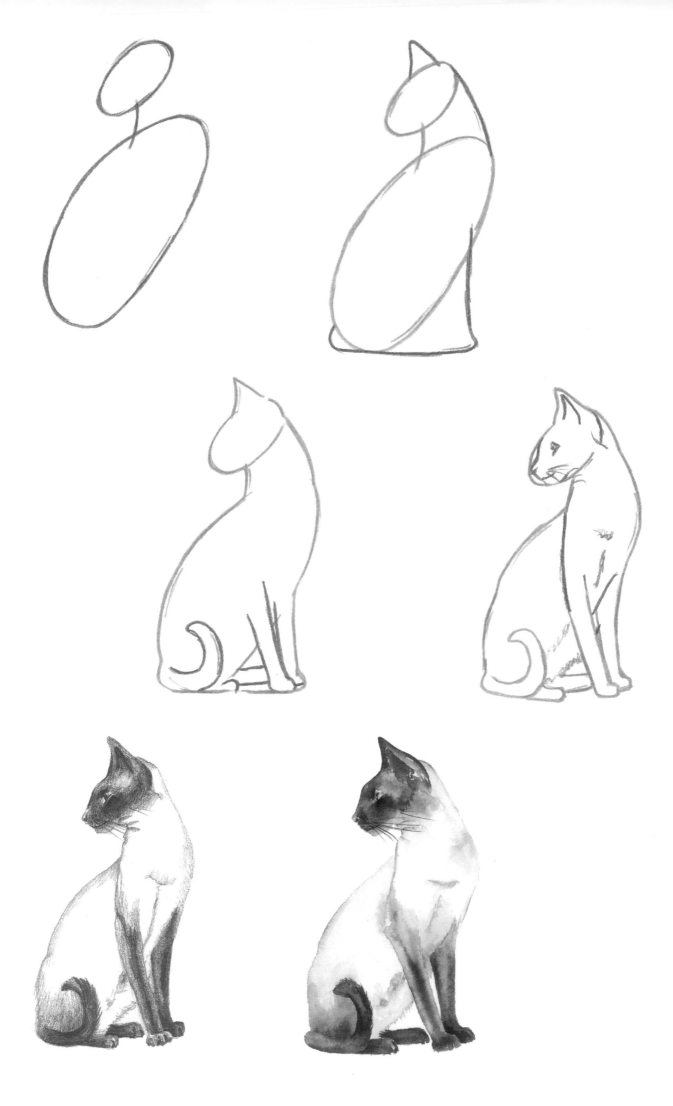

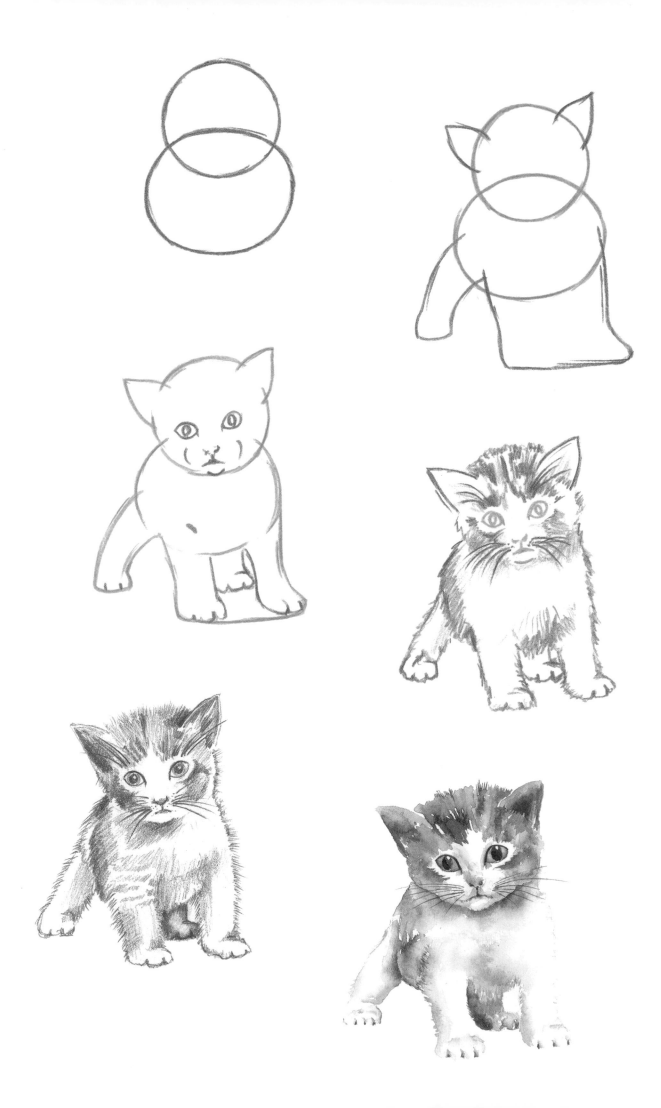

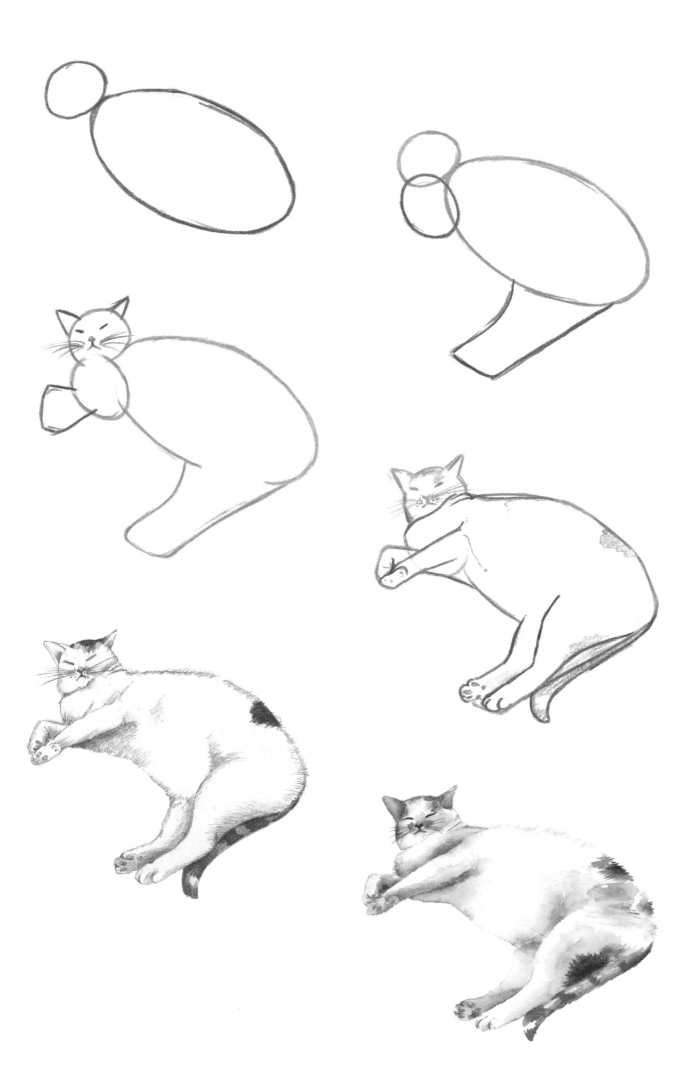

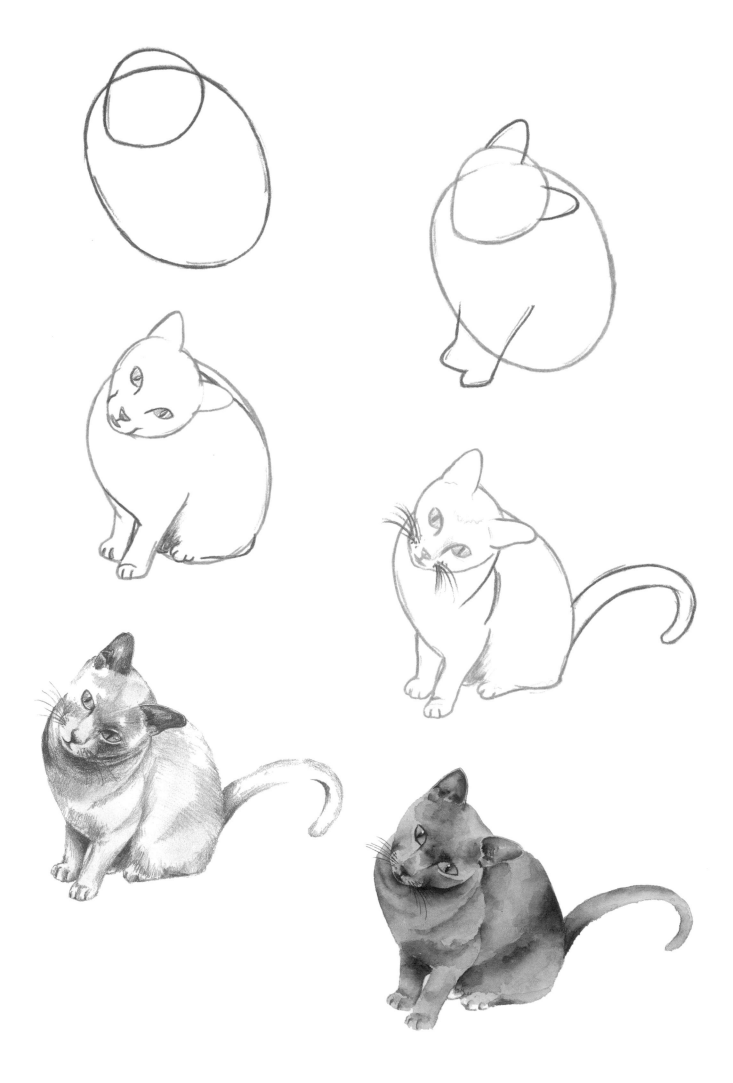

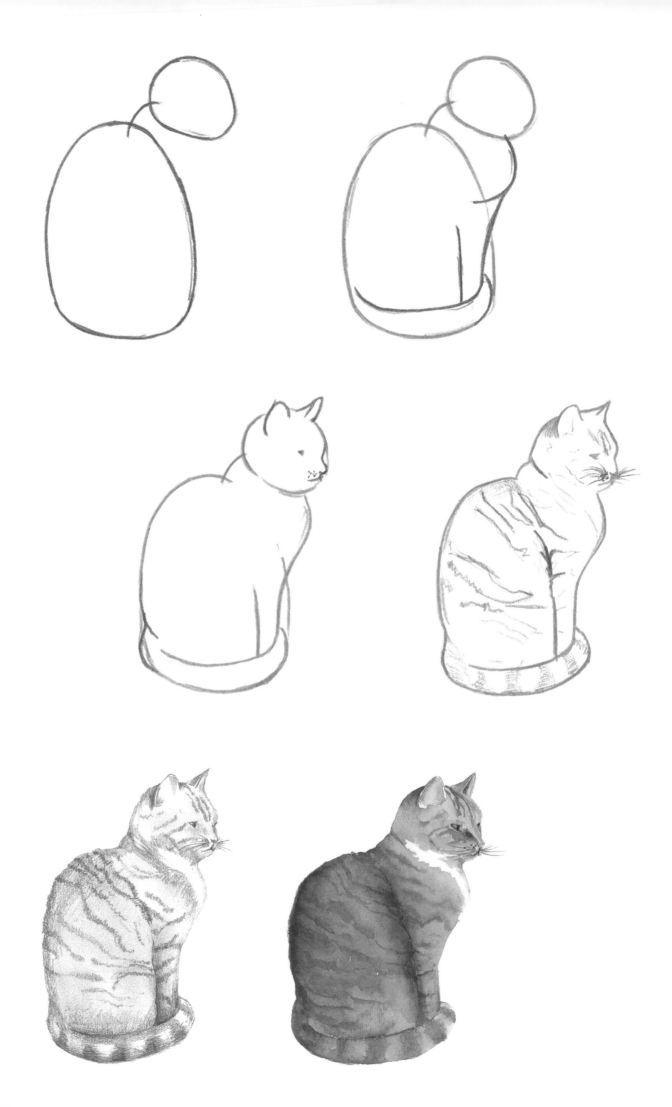

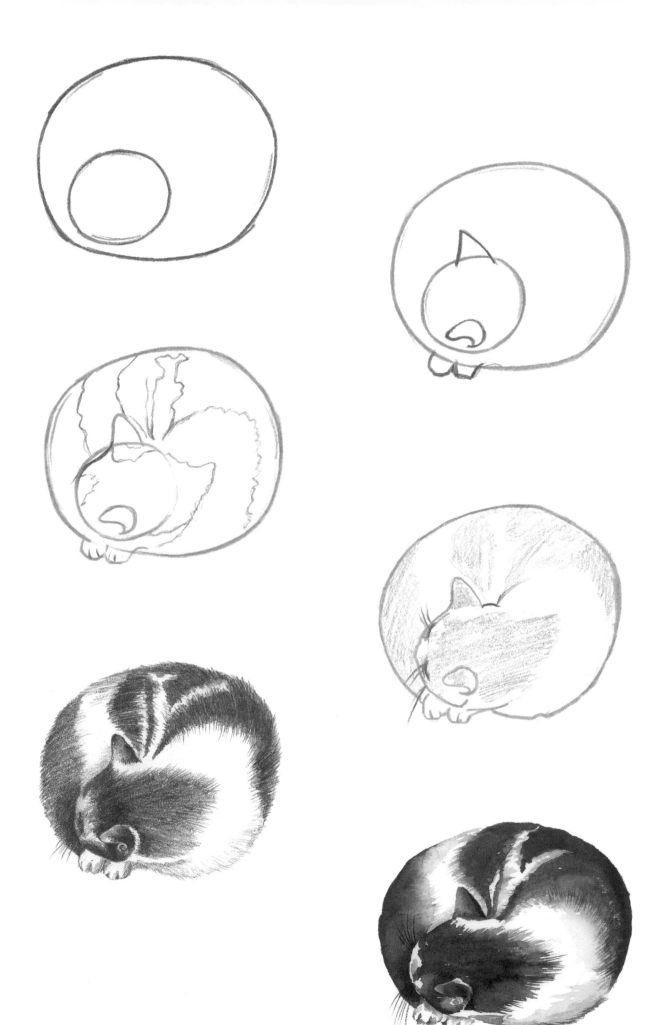

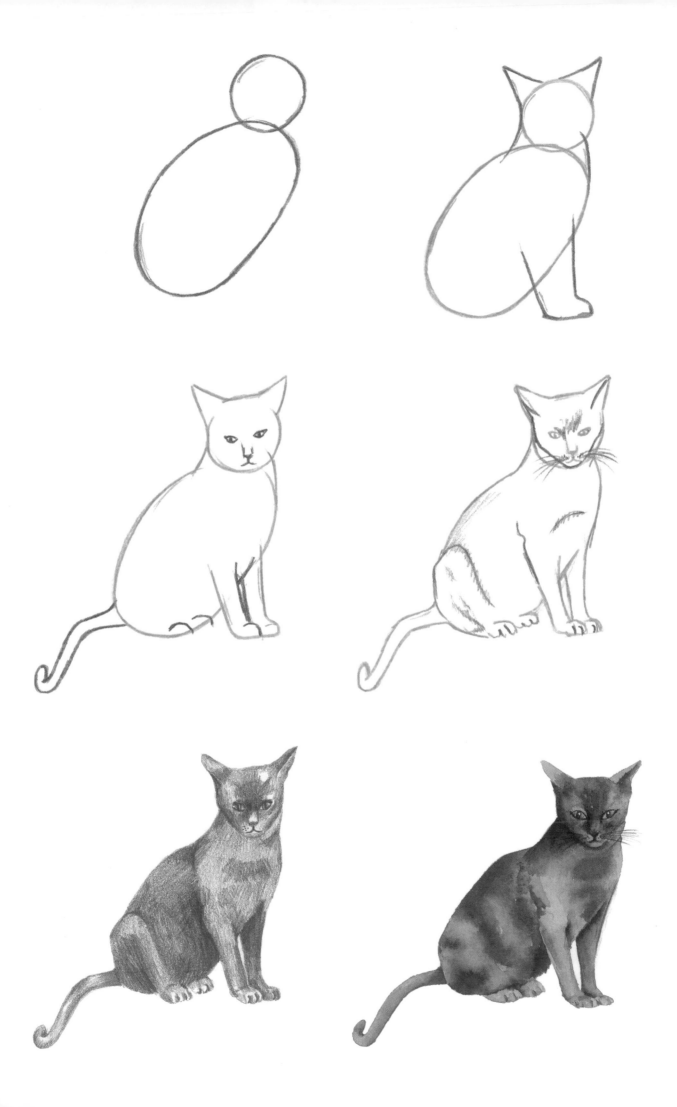

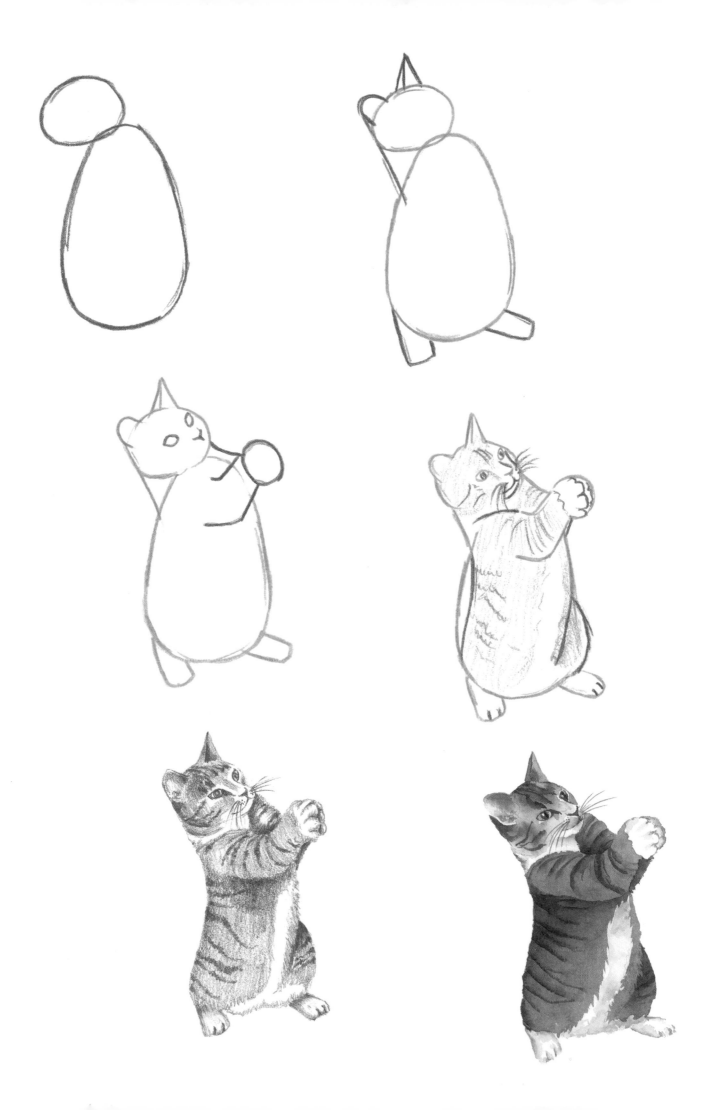

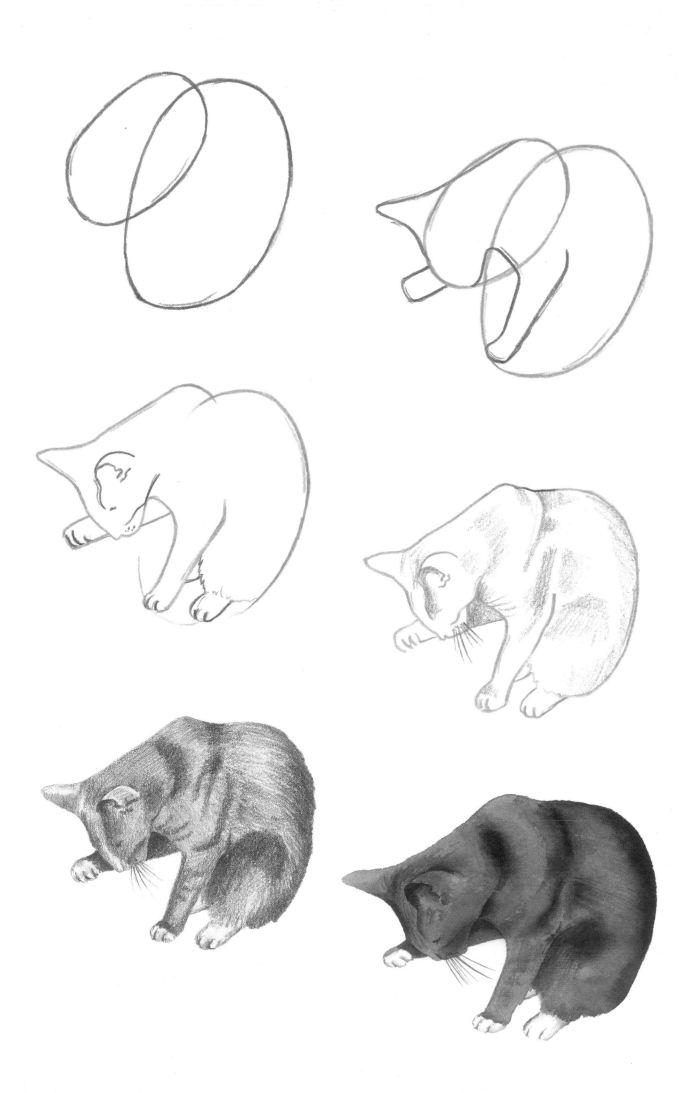